/dedication/
for Maya.

heaven opened up
for you...
special.

you sent right behind you
a call
for the void

to be
filled
with
Joy.

pure and strong--//
you had taught us to
fly.

we came to agreements with god on our own terms.

when this rain falls—
it fall on all our house
(is)
the sun
very far from
where we at right now?

--what do time say?//
can't nobody read—they
counting time...
down to intoxication's
paradise.
it's dismal...

--we got washed clean
in the showers of April...
waited for our
germination to
replace fermentation—
just absorbing
the will
of the god
above.//

...do you think of me?
--at all?

woah.
me
oh
my—

we trapped
right here,
in these boxes—
needing a step ladder.

moving on up—
to the
top floor,
time a little shorter—
than we thought it was.

...learning to forget—
detaching from the carnal::
my spirit soars farther
than my body ever will...
a temple//
mounted to the ground
for the world to admire...
i am not that girl
you thought i was//
do not hold me in boxes—
i will become a Danger
kicking and fighting to escape the
grasps of Definition—
i am not the picture you put together;
i am the puzzle that leaves you
questioning...
unless of course you choose
to accept me as i am
in the moment://

three little birds landed
at the edge of my door
step
talkin bout
you wan reach the peaks of my
Appletree—
you wan' be Tempted to
((see)) like god,
from the top—

your eyes just short of
twenty twenty vision(s)

::perception—
you caught up in my branches
perceiving them as ME

this is Next Lifetime now—
and we've met again...

::we Be(came) again in human form...
but was still butterflies
beautiful from the
cocoons of our past lives//
we was free now—
flying on up
to Canaada...

cool and spicy and dry
Ale gingered—

it's snakes—
and they try to look like us—
try to make magic-//
use speech like us—
telling untruths to satisfy
the ((lack of)) Ego//:

Big talkers//
small walkers—
unlike We::
they have not the favoring
of Our god-//

they jealous
use envy to melt us:://
into pools of Negativity
Still We Rise—

--we had rolled (too)two
blunts//
and smoked our own.
--that's one a piece—
//matched//
that's four.
--took an elevator to Cloud 9.
just three steps short of Heaven.—

::we just balls of light—
spiraling through
space...
riding on a boat
built strong by the love of our labor
to get Over.

...patience—
--pseudonym Virtue.
//thoughts wanna know
do time ever be in a hurry?//
--cuz as fast as shit is moving
i can't see it going
Nowhere—
Clarity//
sitting in my blind spot.
--tryna switch lanes
at (300) sixty miles per hour.

often//
had been made to believe—
--that dreams don't come True.
...yet—
Reality//seeming more like—
Not really—
Real.://
But a
Dream—
and shit.

this love could build a dynasty; but flaw
blinds us.

inspired//
by the urge
to
sense again—

with toes planted
into the ground.

wanting—
to be more of
earth

than before—

go on world tour//
the buzz that shook
the beehive—
too strong a stench to Bear.
oh Honey,
you glowing Golden.

we wasn't drunk in Love—
we hungered for it--//

from the backs of our spines to the
hollows of our belly buttons—

...weariness cloaked our shoulders::
we stayed distant and
were enticed by the ills
of Lust...
crossing paths every so often—

initiating no more than smiles...
left insufficiently
un-complimented by
compliments implied
between smirks of strangers

on an elevator.

there were a few more days than 21 in the
Summer—

and all were hot...
i had thought about
ordering pizza from Sal's...
that had burned down
long time ago—
when Niggas
wanted pictures on the Walls.

--so instinctively to honor the memory of the
rhythm of pain of Hunger—
we fasted,
& replaced the shortcomings of Desire
with Patience's
nutrients.

--& right when we didn't need Love
anymore
i needed a rello
and you had lost
the last of your stash...

--for whatever reason this time we did
not let each other pass,
both of us with intentions to
Elevate
our spiritual faculties...

i know you think about me when you
don't wanna//
i'm smooth—
and have stolen your heart—
you don't say much,
but baby i know...
i know...
well//
it started in a september,
your eyes i can remember
full and innocent
in my gut i felt a tremor;
wanted to be yours—
let you own me...
let go of myself and
just be real—
so real,
you made me feel
from across the room.

i'm shy
oh i'm shy
so i sat back cool—
watched you do what you do—
that thing over there,
like that—
just for me.

you ain't never say so—
but in my mind i knew
it was real and true—
trying to escape perception,
your energy infectious—
the new world dis-(ease)

i'm shy
oh i'm shy
so i sat back cool—
you watching me watching you…

we kids with crushes in
elementary school.

next level.

we had went next level—
you kissed me on my neck-

damn, now why you wanna go and do that?

//repeated//

the act and the show
commenced—

there us was...
tongue tied//
doing everything shamefull—
grown-ups had said don't
do/.

confusion.

music don't sound the same
cuz you keep on//
coming to fruition—
in my
thoughts—
leading to dreaming in the day//
about the places—
we ((could)) go/be—
spiritually you lift me

[six-foot 7]
we standing
thirteen feet hi(er)
than the average—

built to last,
made of Go(l)d

not glass.

i had envisioned you in my future
in my past.

i heard somewhere//
in your tone/
of Voice—
that you wanted to be free from the
constraints of expectation...

i let you loose—
you//
Regal—
moving strong and silent...

i love that shit...

so i enjoy as i receive—

and you begin to
be a fuller you,

more than i had thought of
in the mind of me.

the itch of insecurity taunts me for succumbing to sensation.

//before//
--when niggas
ain't do Right...

i robbed the World of my Light—
took it back,
tucked it deep

so my shame wouldn't show up
--i washed and scrubbed the
dirtiness of the trust
mis-held
there...
in my palms.

((self-ish))
thinking of me::

like they forgot to do--

/robbed them
and me too—

shine buried so deep
not even me could see...

not even when tears advanced
from the windows of my soul...

not even then
could i see what i carried—

not Good enuf
keep thinking
i
is not Good enuf.

me became evil/
like Jealousy.//.

you a song i want to sing
and i got a different sound...

--and when the Light
resurfaced for a glimpse
at Life later,
we went to war.
kept on wanting for those things not
included in packaging—

seeking a me that never was
or was supposed to be...//

re-reconciled my insecurities
and transformed them to
purpose...

making shifts
with a non make-shift self...

re-found, untouched,
untainted.

seeing auras around you—
melt me down like chocolate,

that smile break the locks
holding all my secrets

we get on a wave strong,
surfboard.
surfboard.

balance impeccable,
//could you get lost//
with me?

wading into a warm
tide—

coverage tighter than
a cove.

[[when the love became reciprocal]]
and you loved me how
i loved me....
you told me i was sweet—

said i was the honey to your tea,
the icing on the honey bun
honey bun, when did you

let go of you like i
let go of me...

embraced and switched places—
this right here is
the Next Life Time///

seeking will leave you lost—let go and receive.

--who ever knew the candy lady sold
grown ups lollipops
too?//

the whole time we was distracted—
picking from nickel and dime
bags while
the
big people
picked from
nickel
and dime bags---

now we drug fiends
and don't know why—
can't make human friends and don't know
why//
intoxication be more trustworthy
than our next door
neighbors.

//i cant handle my liquor—
and this man know that—
//so he sticks to the Weed—
with me//

you see right through me my nigga...
tell me all about it—

clouds forming
and you be the silver lining
to all of them--/
i'm just tryna get a contact

--can you touch me?—

intellectually?
or nah?

i'd like to ride a cool summer's breeze—
just long enough to make
a happy cry…

removed from all the pain
that built me :::

free flying over tree tops—

a bird un-caged

and soaring

www.ingramcontent.com/pod-product-compliance
Lightning Source LLC
Chambersburg PA
CBHW041243200526
45159CB00030B/3059